COLORING BOOK FOR EN GOOD COOL COLORING BOOK FOR EN GOOD COOL COLORING BOOK FOR EN GOOD COOL COLOR COLOR EN GOOD C

Coloring Bandit

Copyright © 2017 by Coloring Bandit All rights reserved.

No part of this book may be reproduced or used in any way or form or by any means whether electronic or mechanical, this means that you cannot record or photocopy any material ideas or tips that are provided in this book

Published by Speedy Publishing Canada Limited

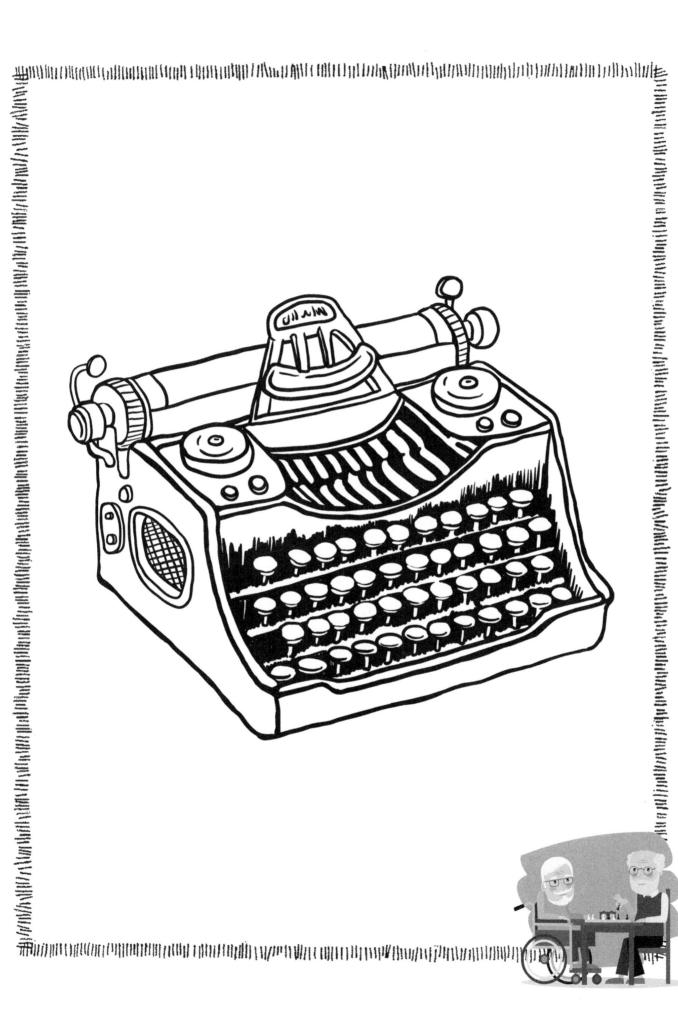

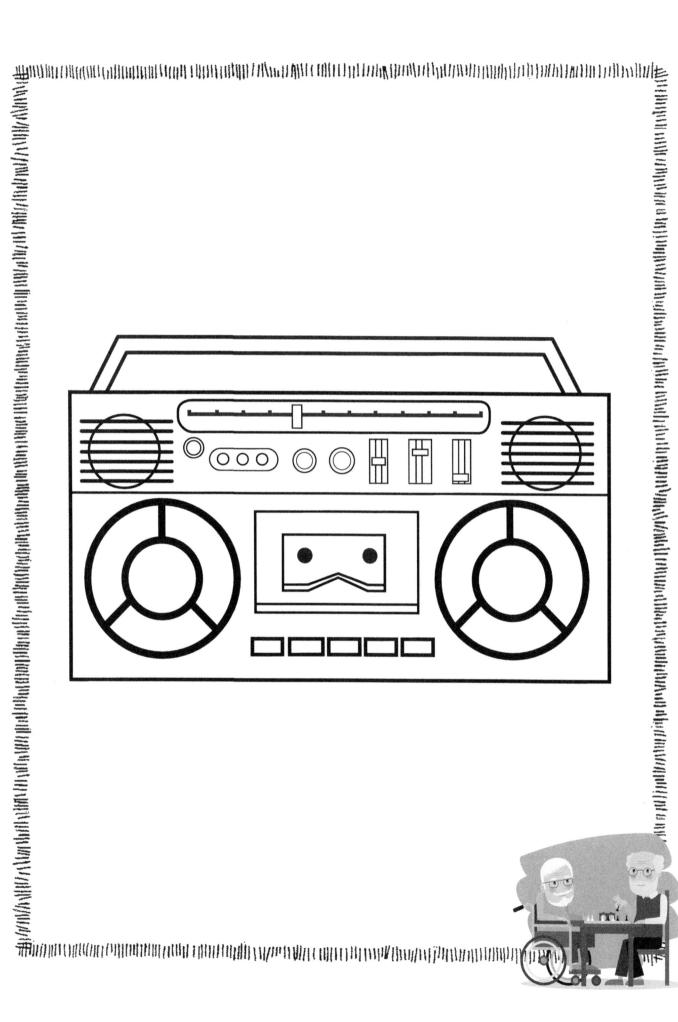

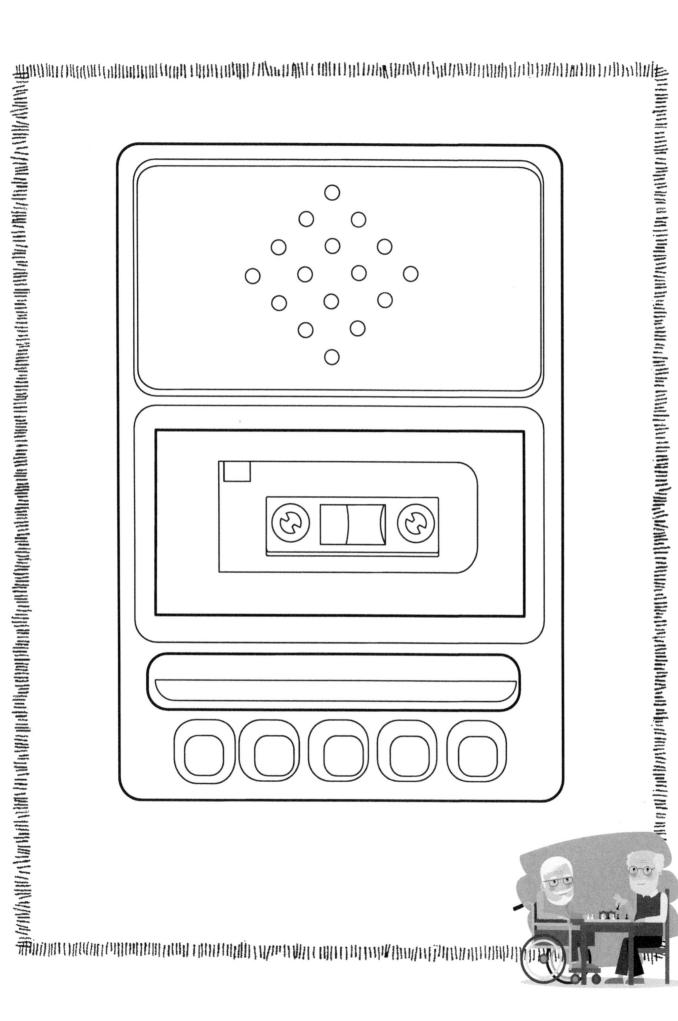

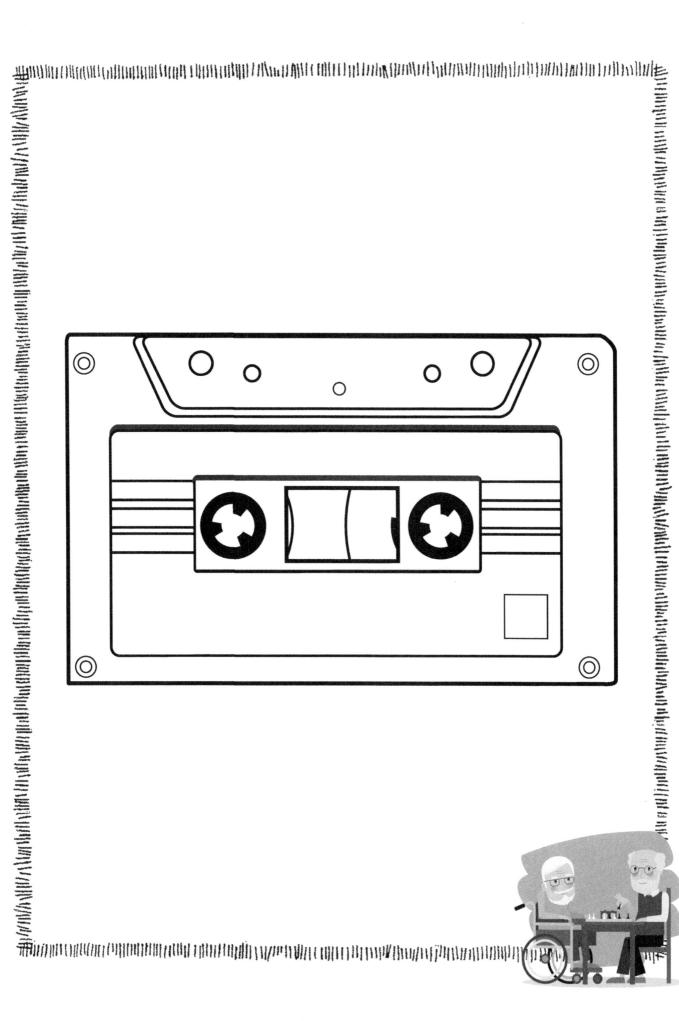

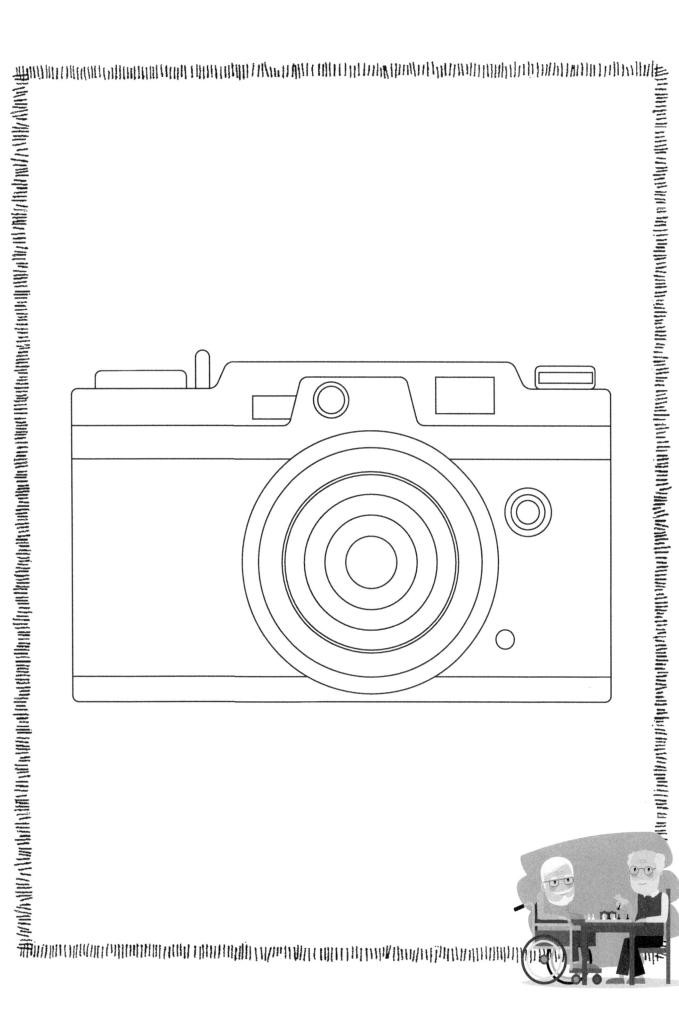

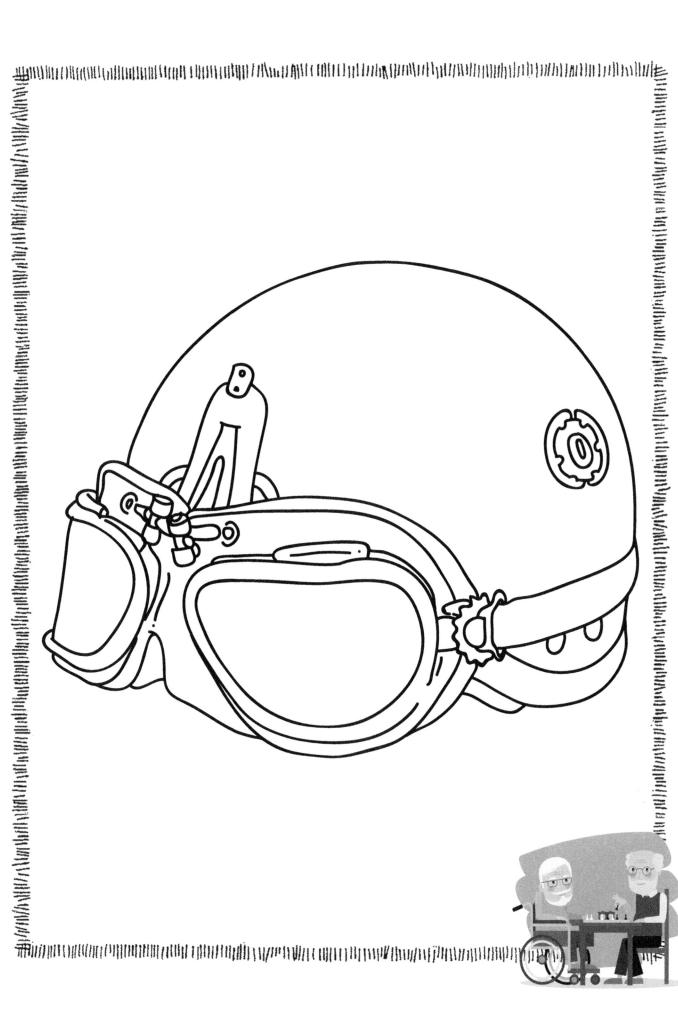

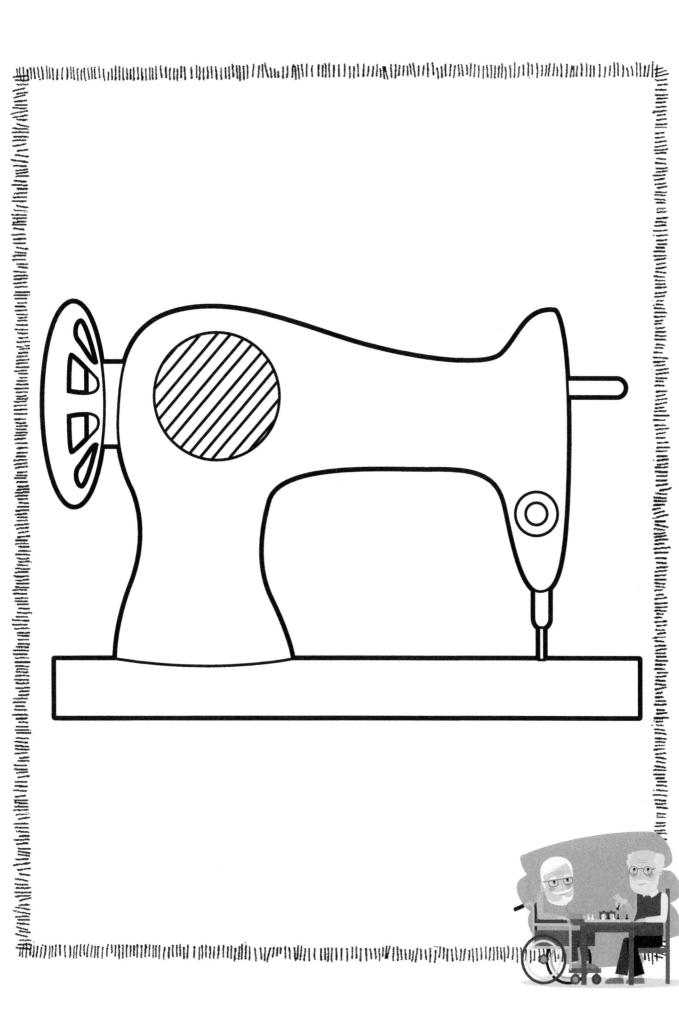

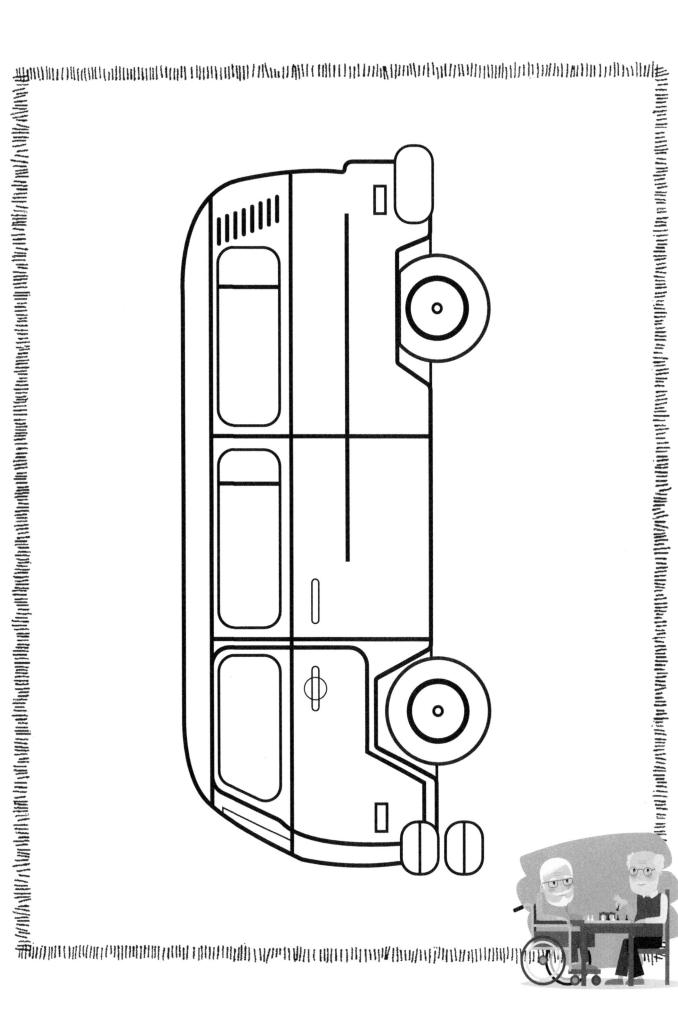

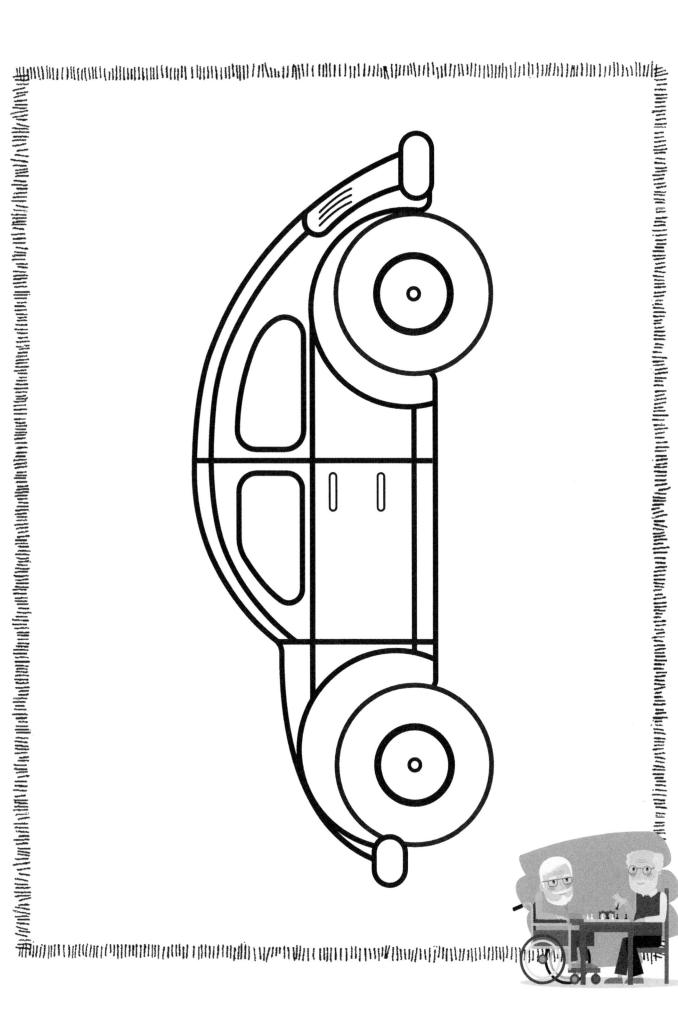

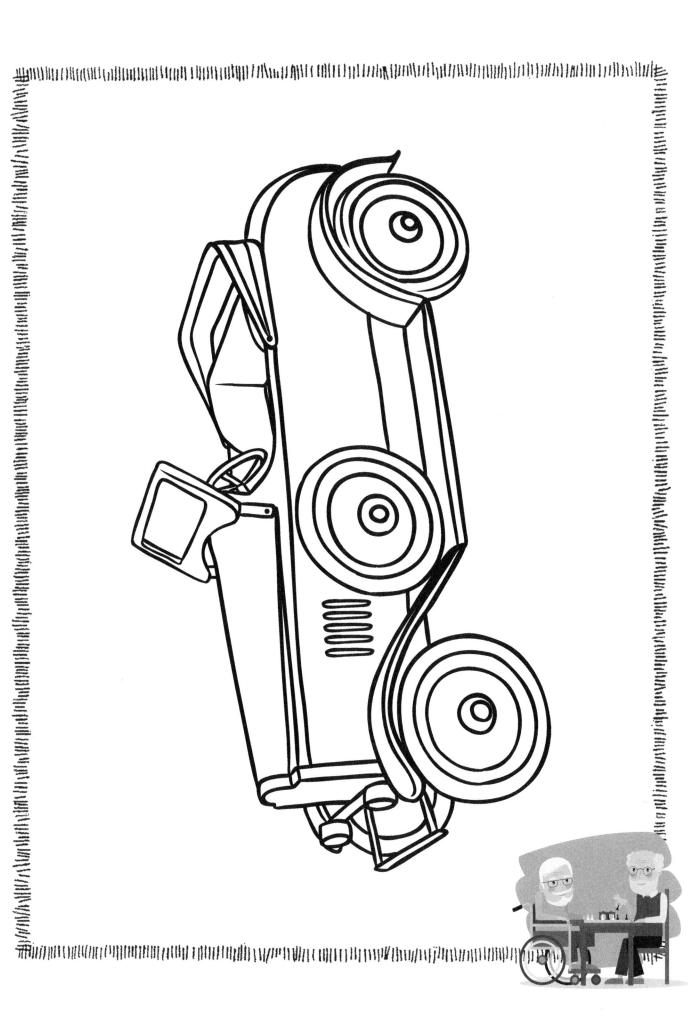

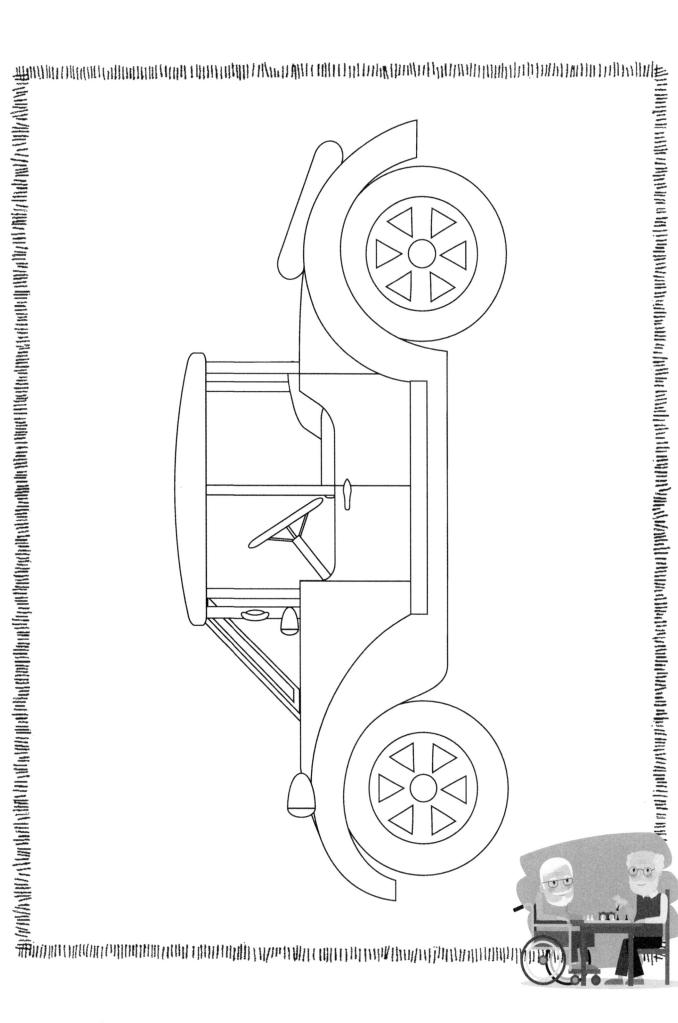

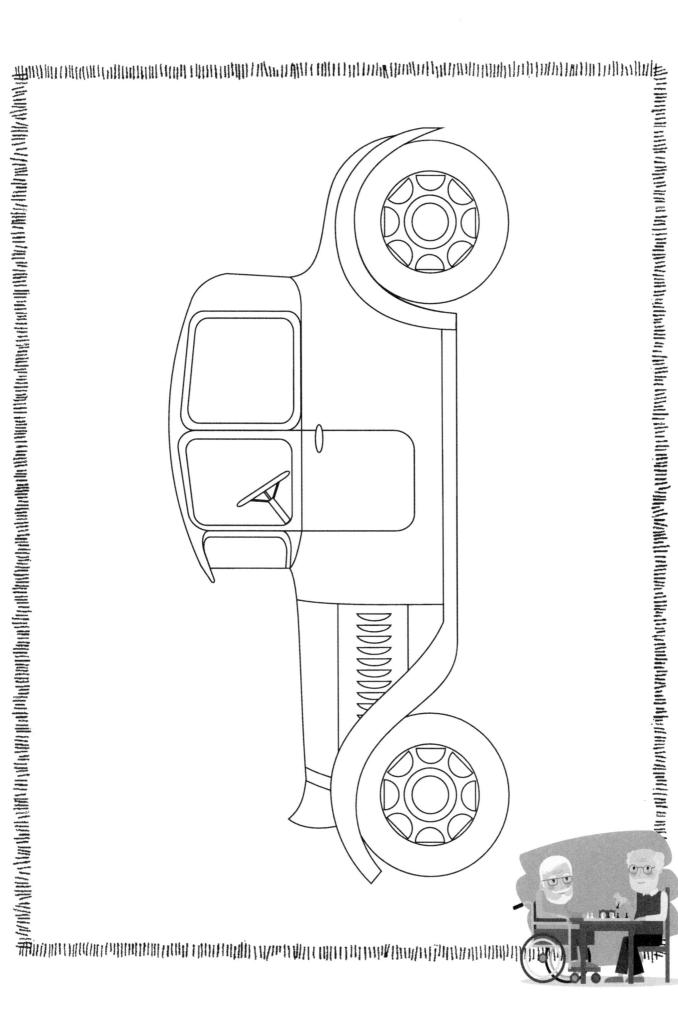

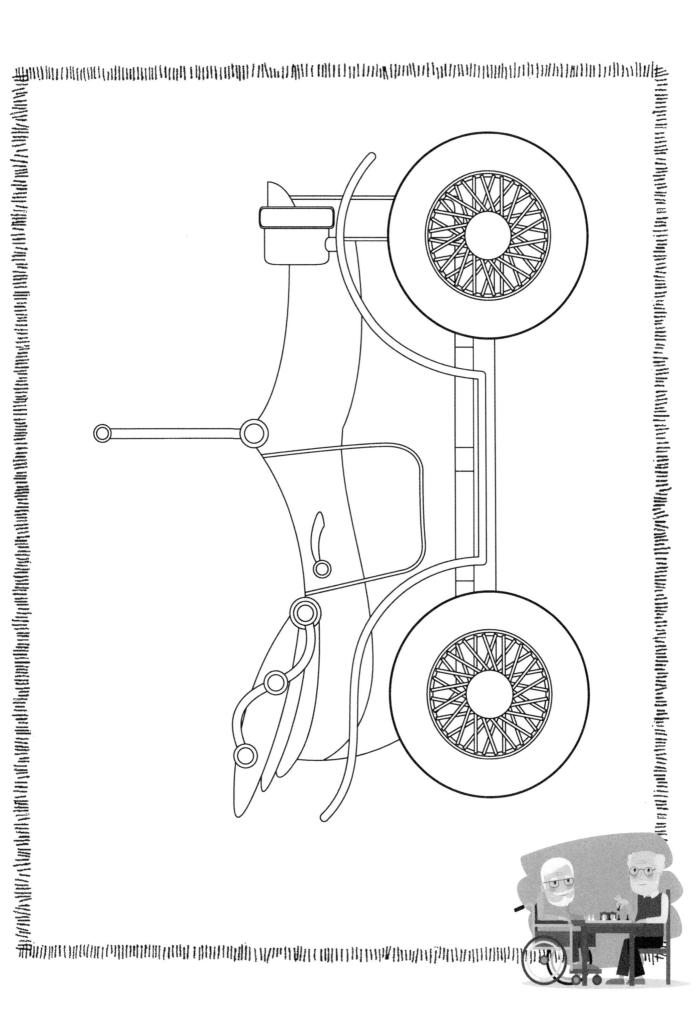

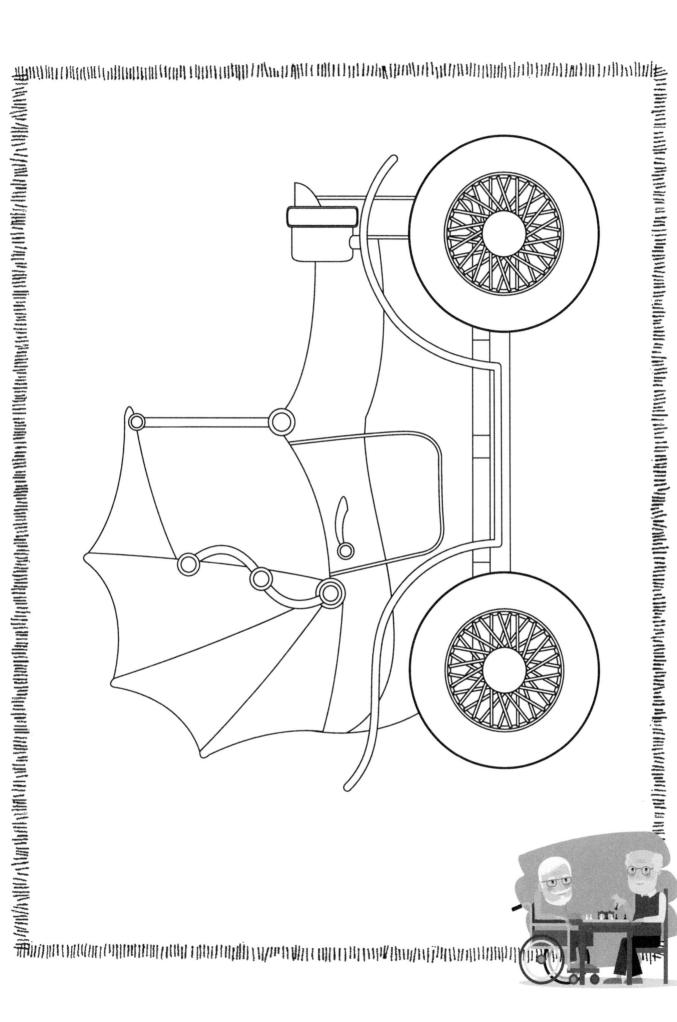

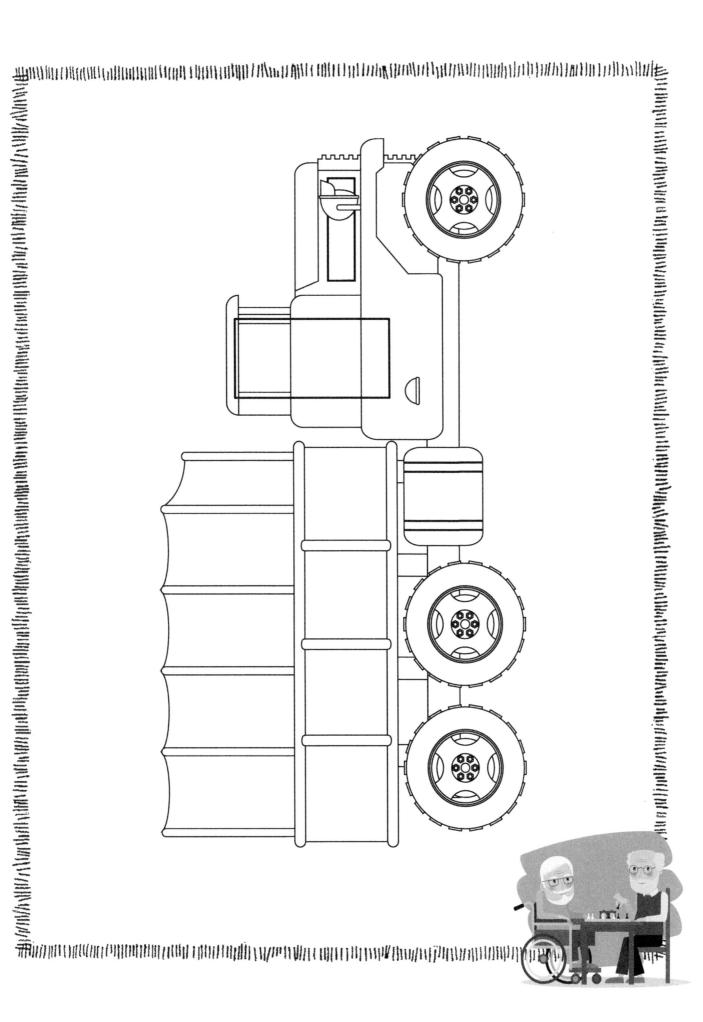

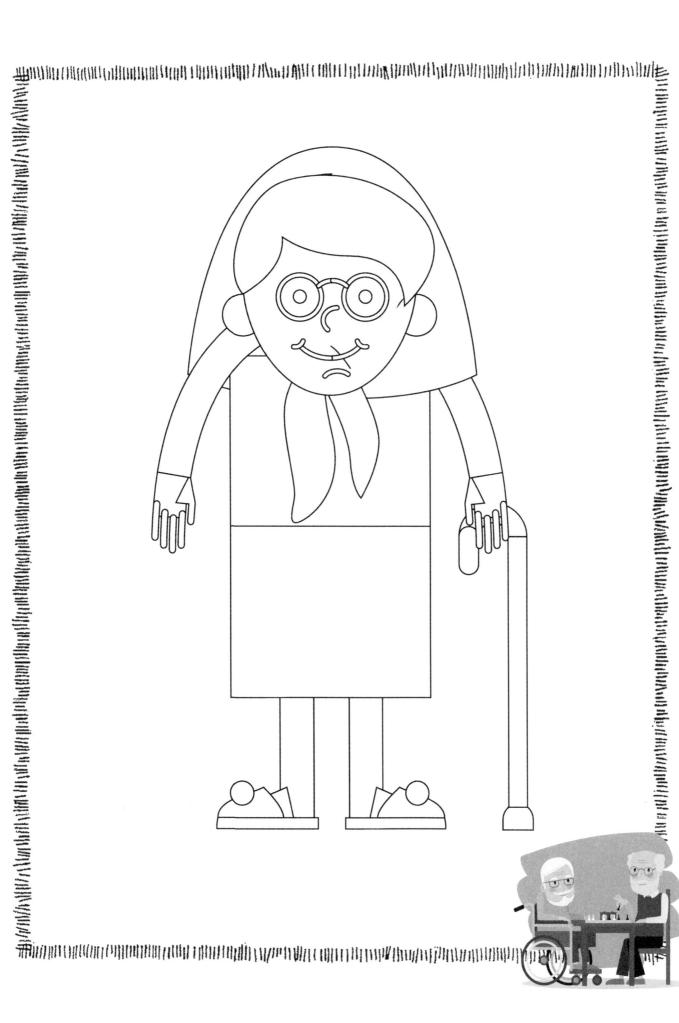

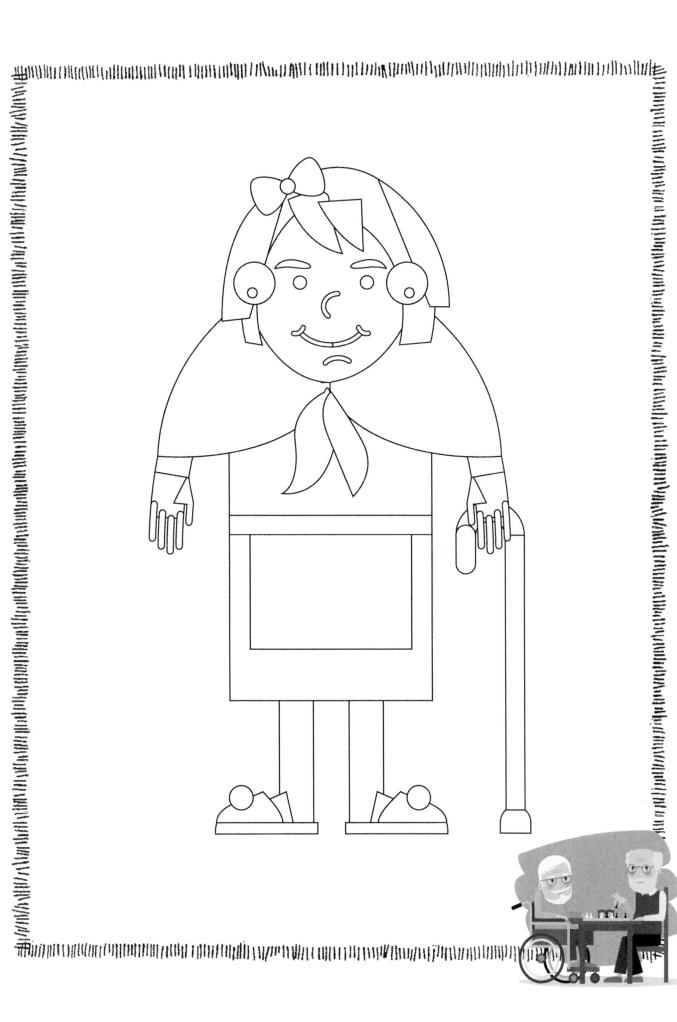

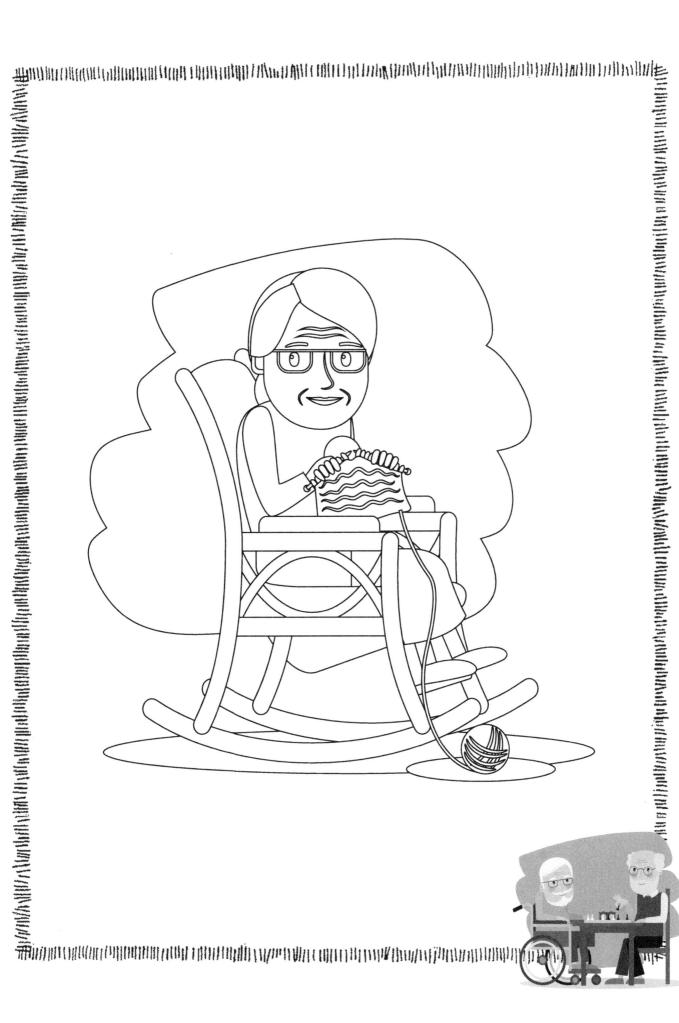

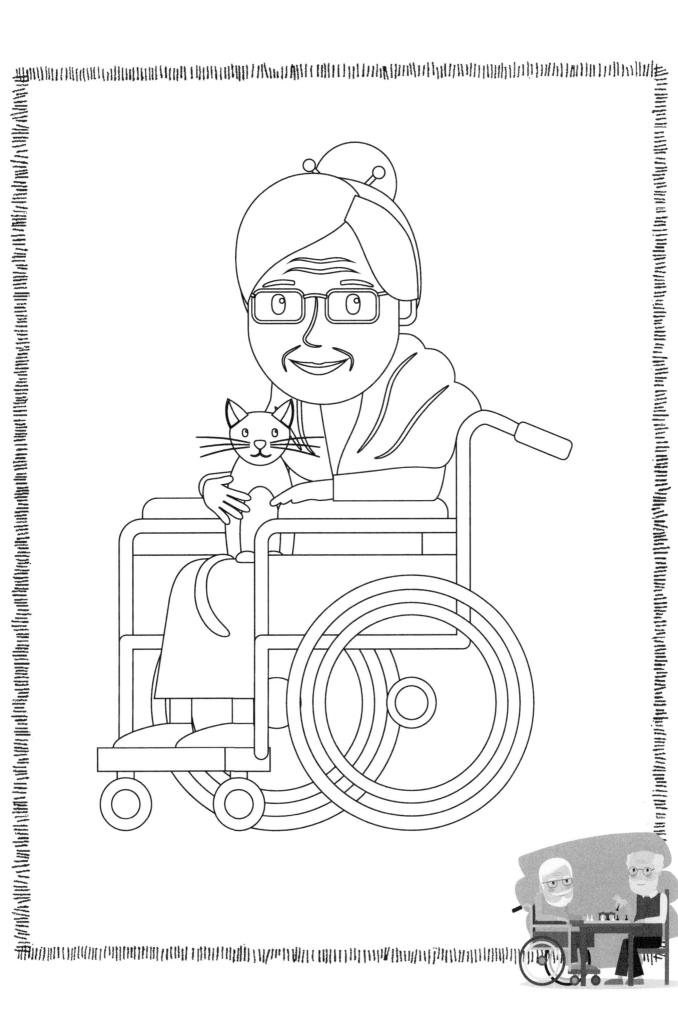

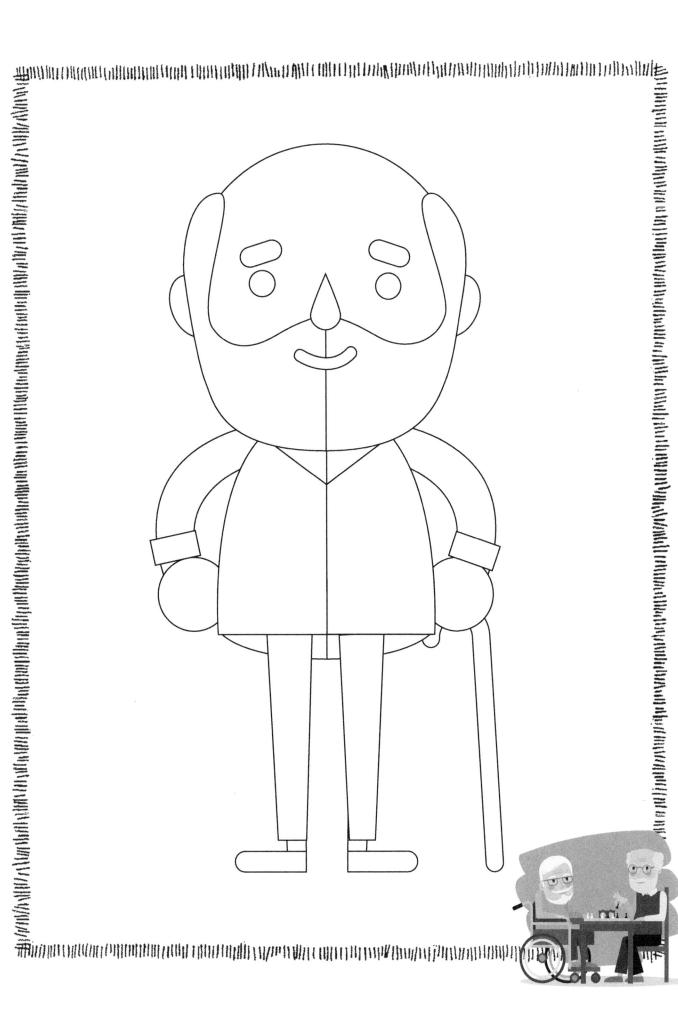

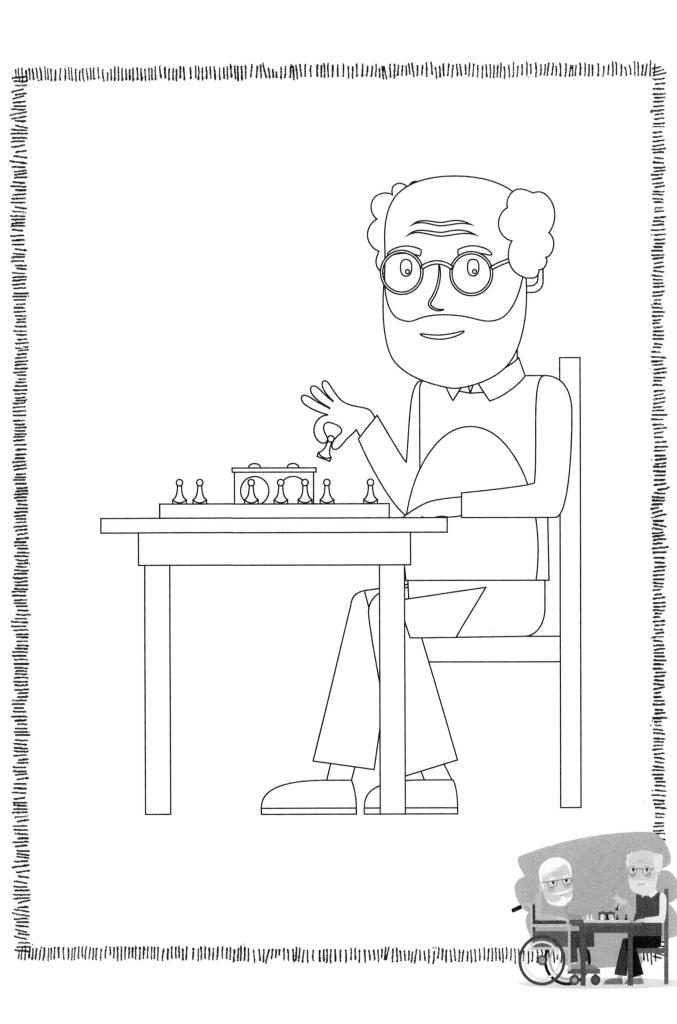

The control of the co

Printed in Great Britain by Amazon